In Search of the Miraculous or One Thing Leads To Another
Milton Glaser

OVERLOOK DUCKWORTH
New York • London

Acknowledgments:
Many of these pieces were created over the last five years
working side-by-side with my splendid and admired studio
collaborators, Molly Watman, Sue Walsh, and Nick Pattison.

Virtually all the photographs were taken by Matthew Klein,
who has had this responsibility for forty years.

Additionally, Martin Schweizer and Kevin O'Callaghan were
enormously helpful in developing the dimensional aspect of
these projects.

This edition first published in the United States and the
United Kingdom in 2012 by Overlook Duckworth

NEW YORK:
The Overlook Press
Peter Mayer Publishers, Inc.
141 Wooster Street
New York, NY 10012
www.overlookpress.com
For bulk and special sales, please contact
sales@overlookny.com

LONDON:
Duckworth
90-93 Cowcross Street.
London EC1M 6BF
www.ducknet.co.uk
info@duckworth-publishers.co.uk

Cataloging-in-Publication Data is available from the Library
of Congress

A catalogue record for this book is available from the
British Library

Manufactured in China

ISBN 978-1-59020-722-2 US
ISBN 978-07156-4299-3 UK

After Chen Ning Yang and Tsung-Dao Lee were awarded the Nobel Prize in physics in 1957, the science writer Jeremy Bernstein, himself a physicist, published an article in *The New Yorker* telling the story of their research into the laws of parity that led to the discoveries for which they won the award. The story was compelling even for readers who knew no physics and had never heard of parity or its laws. The designer Charles Eames said, "Everyone who wants to understand the creative process should read this article."

Earlier this year, walking and reading my way through an exhibit at the New York Chapter of the American Institute of Graphic Arts (AIGA) of Milton Glaser's recent work, I remembered Eames's pronouncement and thought, "Everyone who wants to understand the creative process should see this show." Now, with the publication of this small book, they can.

Milton Glaser did not invent the tee shirt or the bumper sticker. But wherever you are it is almost impossible to escape seeing one of the myriad surfaces that display variations, parodies, or brazen rip-offs of the iconic I Heart New York rebus he designed in the seventies. In the public mind that's probably what Glaser is best known for. Having contributed a brief essay to a book called *I Heart Design*, I suppose I have no right to complain about that, but I complain anyway. The design may deserve its universal popularity, but Glaser deserves better.

If there were an award for the world's champion graphic designer, Milton Glaser would surely win it. Fortunately there is no such award. It would be a meaningless title, although absence of meaning has not stopped the current proliferation of design awards. Glaser certainly has had his share of them, but his leadership in the field is not just a reflection of the distinguished body of work he has created, but of the values he promulgates as one of the design community's most eloquent spokesmen. No one is more effective than he at clarifying the thorny issues that make design difficult to do and to understand. He knows how design happens, and why, and says so with a practiced conviction.

He says it in a variety of ways, some of them funny, for the humor that informs much of his work is intrinsic to both his private and public persona. Milton is a superb teller of jokes and narrator of comic situations. Speaking at an AIGA convention a few years ago, he observed that, in the many times he had addressed the organization, the most favorable response by far greeted his description of how his mother cooked spaghetti. So

he described it again. Milton's account combines the flavor of the best Jewish-mother jokes with what must be the worst recipe known to culinary legend. I believe it even has some relevance to design, although frankly I can't remember what it is. When the laughter faded, the anecdote was followed by a sober analysis of design responsibilities.

Don't knock it until you try it. —MG

Because of the clarity with which he perceives the process that all designers share, Milton Glaser is unsurprisingly the best exegete of his own work. This book is a case in point. It is based on, and shares a title with, the exhibition *In Search of the Miraculous or One Thing Leads to Another*. Milton wrote the text for the show, which—a rarity in exhibition text—actually illuminates the work shown. The book, like the show, celebrates the unpredictability of creative action. The title and subtitle are personal, the former a phrase recalled from Glaser's early reading. When it comes to design, I find miracles suspect. Once, when speaking at a university design conference, I was preceded by a speaker of New-Age proclivities who zealously exhorted students to "Design a Miracle!" As soon as he finished, I urged them to disregard his advice, arguing that a miracle, by definition, occurs outside constraints, whereas design operates *within* constraints and that one of the designer's first tasks is to discover what they are. I think I would make pretty much the same argument today; but if the zealot had told the audience to design not a miracle, but something *miraculous*, I'd be much less likely to object. Artists and designers regularly pursue the miraculous, and sometimes find it, or at least something close enough to it to justify the search by sparking an image that the searcher hasn't found, but has created. This book abounds with examples.

When designers present the body of their work it can come off less as a body than as a series of component parts: *I did this, and I did this, then* ... Instead of offering up a series of discrete accomplishments, Milton usually sees and shows his work as a developing continuum. One thing literally leads not just *to* another, but *into* another, so that the effect is not a product but a pattern of growth. In this sense it is literally a search, an adventure incorporating the false starts, wrong roads, and missed turns that are part of *every* adventure. If the miraculous is to be found or made, it will be in the searching.

Yet, faithful to the subtitle, the book actually does show how one *thing* led to another. An aspect of the creative process that is rarely discussed by writers and artists is the incessant recycling that goes on in the pursuit of any craft. Critics frequently probe books and pictures for evidence of conceits or motifs that have been heralded in earlier works by the author, as if the exploitation of past creations were somehow shameful evidence of a poverty of present ideas. Creators themselves speak of "cannibalizing" their own work. Glaser is singular in acknowledging—indeed, even insisting—that themes and ideas used earlier reappear in forms vastly different from the original, and that their rediscovery is a consummation devoutly to be wished. A book-jacket design done in the sixties can be recognized in the identity of an art museum that opened in 2004. Some experiments in pattern-making turn out to be useful in rugs for a Tibetan rug company and in the carpet for a theater renovation.

Books by an artist about his or her own work focus naturally on the forces that inspired and animated the work and on the forms

it took as it moved into a life of its own. Glaser does this of course and would be remiss not to. But he is a professional designer as well as an artist, which means that much of his productivity is in the service of clients whose objective may at times collide with creative flow. So one section of this book deals with work that has been rejected. Called "The Client Didn't Get It," this section acknowledges the professional requirements of intelligibility and acceptance, while recognizing that many of our most nourishing ideas are experimental (which means that they often don't work) and ambiguous (which means that they often fail to communicate with the desired clarity). "Failure and ambiguity," Glaser wryly notes, "are difficult ideas to sell to a client who simply wants to move more cans of tomatoes."

Common sense tells us that tomatoes must be moved. The creative impulse tells us that so do people. Milton Glaser's gift is to satisfy both.

Ralph Caplan, *May 2011*

IN SEARCH OF THE MIRACULOUS OR ONE THING LEADS TO ANOTHER

I remember reading Ouspensky's book on Gurdjieff as a young man. I found it strangely unpleasant and unconvincing for reasons I don't understand, but the phrase "In Search of the Miraculous" has persisted in my memory. One could easily say that all human experience is a miracle: memory, color, taste, walking, skin, affection, Vermeer, stars, watermelon and so on. For those of us in and around the arts, the act of making things that move the mind is our deepest aspiration regarding miracles.

The second title evokes another idea, which is to contextualize the works, in order to better understand them. This is usually done retrospectively after the artist's death, but that seemed problematic. I've chosen work, largely produced over the last five years, to demonstrate how one thing leads to another. It's fascinating to discover that something you thought was a brand new idea actually had its root 35 years earlier.

In the sixties, I started studying Kundalini yoga with a guy named Rudi [1], who owned an Asian art gallery on Fourth Avenue in the East Village. Kundalini yoga is all about releasing the serpent energy that resides at the base of the spine. I learned a lot about the relationship of art and energy from him.

At one point, I did this book jacket for his provocatively titled *Spiritual Cannibalism* [2].

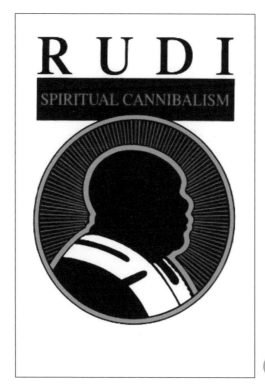

2

In 2004, I was asked to design the identity [3] for the Rubin Museum of Art. A three-dimensional version of that identity appears on the façade [4].

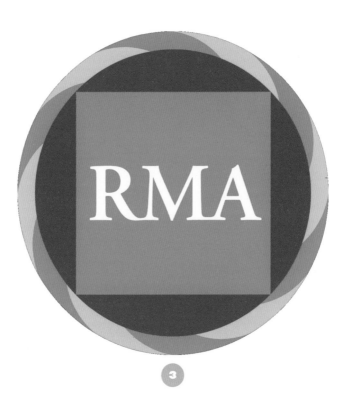

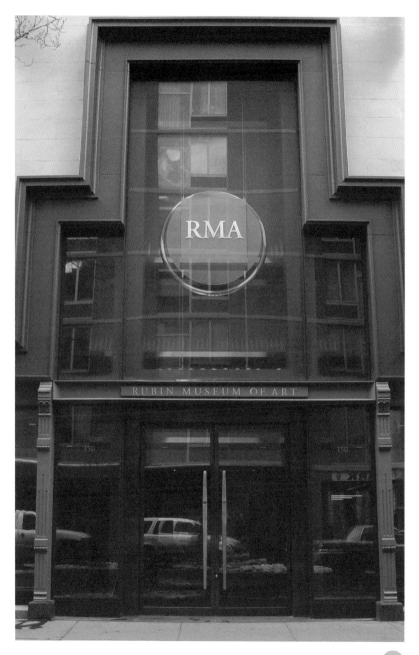

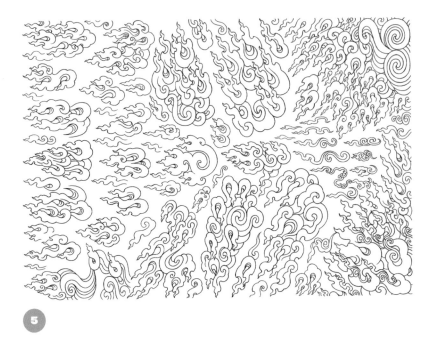

5

I also developed a 17-foot gilded copper wall based on drawings of Tibetan clouds [5], shown here in a paper study [6] and in its finished form [7].

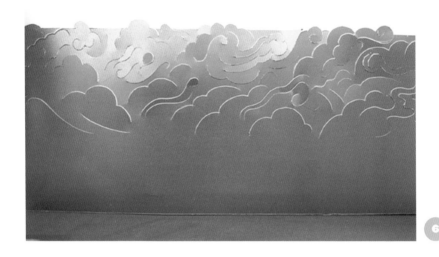

6

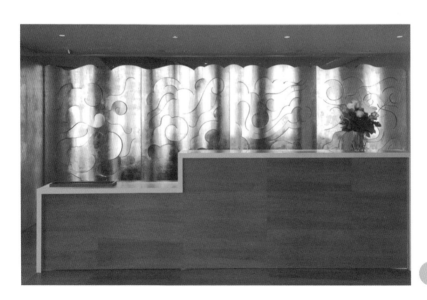

7

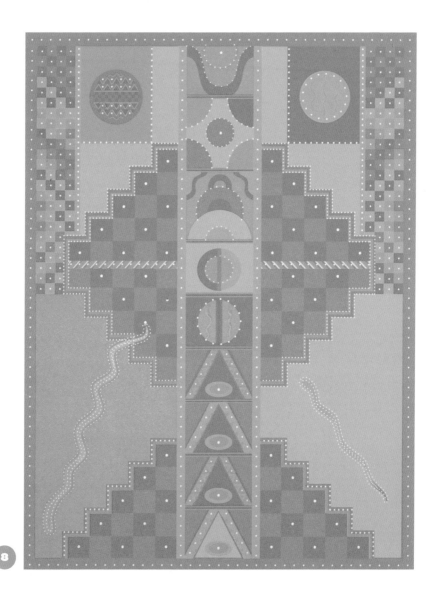

8

The museum also commissioned a series of silkscreen prints including *Light Tantra* [8] and *Dark Tantra* [9].

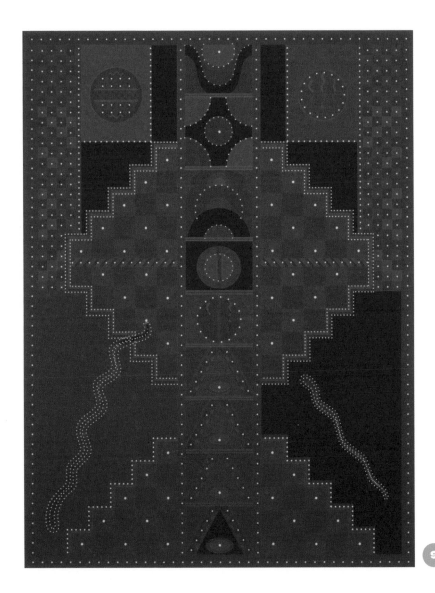

9

Signs outside the building consisting of enigmatic statements [10] were executed in the same geometric spirit as the logo. A poster [11] for a Buddhist film festival is based on the "thousand Buddha" imagery that occurs in many Buddhist paintings.

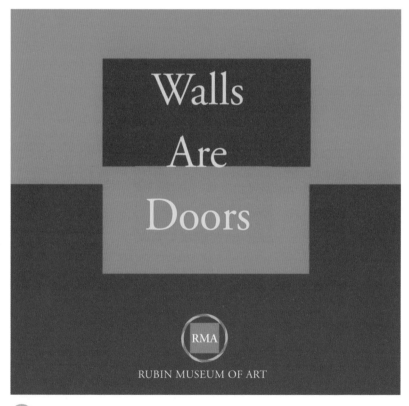

10

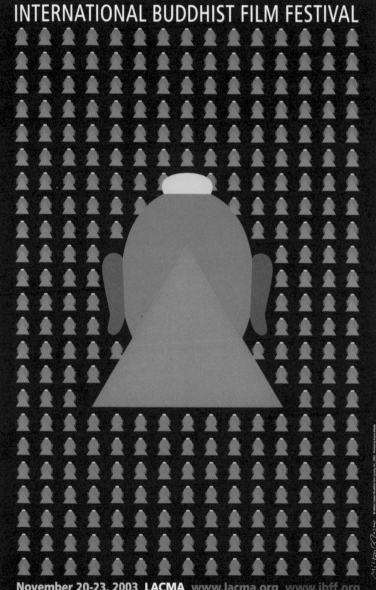

As a result of my interest in pattern-making, which began with these museum projects, I began to design a series of variations, including *Dutch Dark* [12] and *Dutch Light* [13]. A short time after the Rubin Museum was complete, a swami and former disciple of Rudi's, Michael Shoemaker, who had an interest in a Tibetan rug company, arrived at the studio and asked me if I had any designs suitable for handmade rugs. Up until that point, we had no application for the patterns we had been making. Unexpectedly, a purpose materialized and we started to find other uses for the work we had done.

12

13

The Light and Dark *Tantras* became full-size rugs [14]. *Dutch Dark* became a carpet [15] for the School of Visual Arts Theater renovation on 23rd Street.

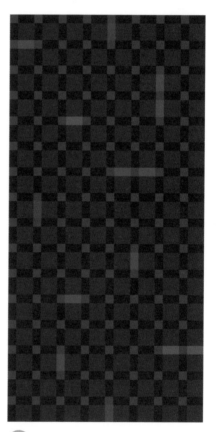

15

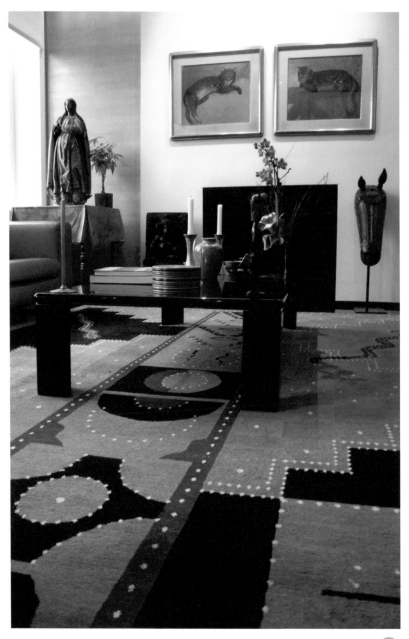

My apartment.

One of the seminal architectural works of the early twentieth century, Vladimir Tatlin's *Monument to the Third International* [16], had long fascinated me, and I created a series of studies based on it [17, 18, 19]. The final logo for the theater [20] is a stylized version of the 18-foot, 3-ton kinetic sculpture which appears on the top of the marquee [21].

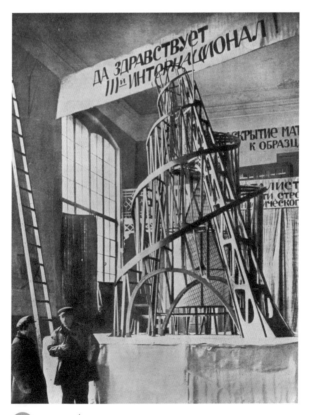

16

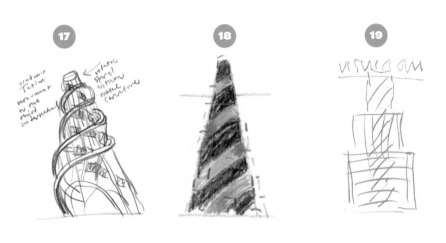

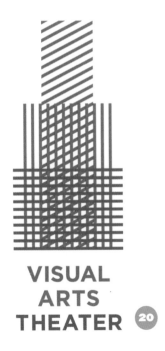

**VISUAL
ARTS
THEATER** 20

All of the Theater elements and the kinetic sculpture could not have been realized without the passionate involvement of Kevin O'Callaghan.

The sculpture rotates every hour on the hour while displaying a commentary about the nature of time [22]. For example, "Today is the tomorrow you worried about yesterday."

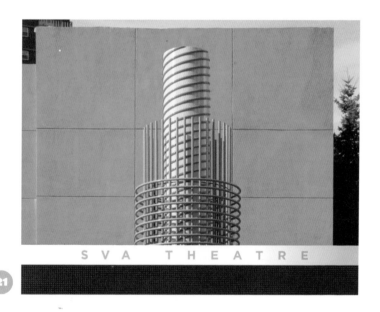

21

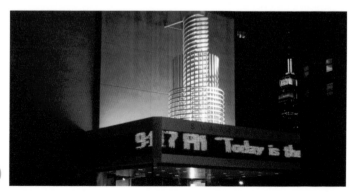

22

An early and unresolved sketch for the façade [23] included the idea of doing a changeable mural on the side of the building [24]. The subject is "The Secret of Art." At the moment, this proposal is still seeking approval from the city. Ironically enough, the issue under consideration is whether it is a sign or a work of art.

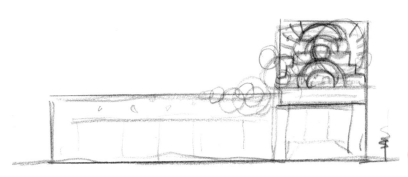

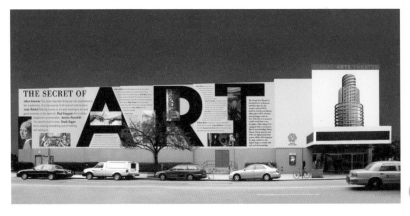

An early study for the interior consisted of not much more than a series of colored paper shapes pasted over a photograph of the partially dismantled interior [25]. The demolition had revealed a series of dramatic concrete forms, which we decided not to change [26]. The furnished interior has a serpentine steel wall with a powder-coated finish that defines the space. What amazes me now is how similar the spirit of the sketch and the final interior turned out to be.

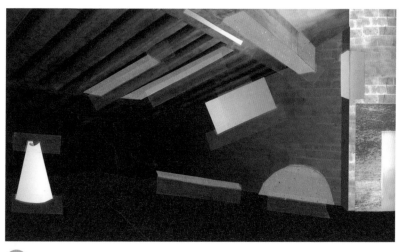

25

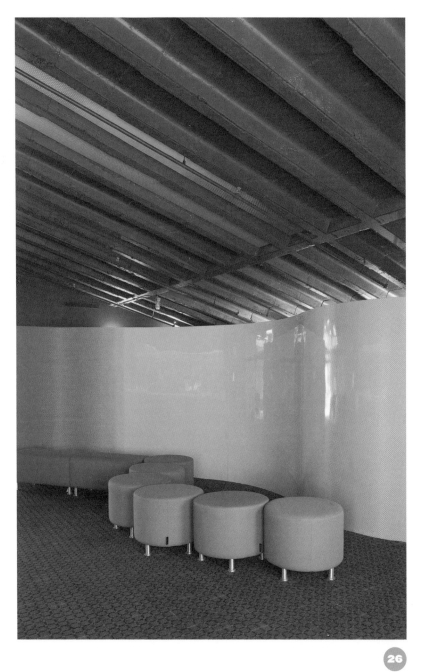

The wall includes a pattern originally developed as a rug with color variations [27].

I simplified it for use in the space [28] and applied the dots to metal panels [29].

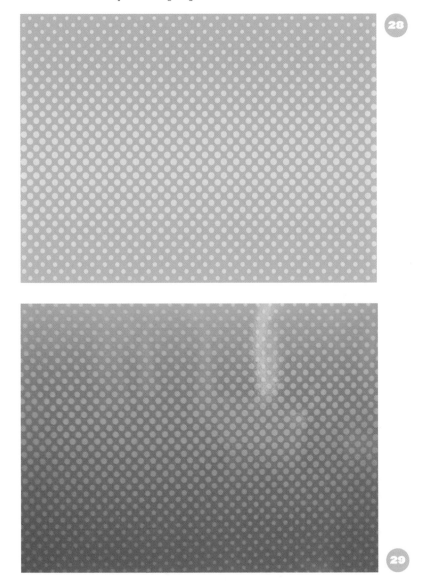

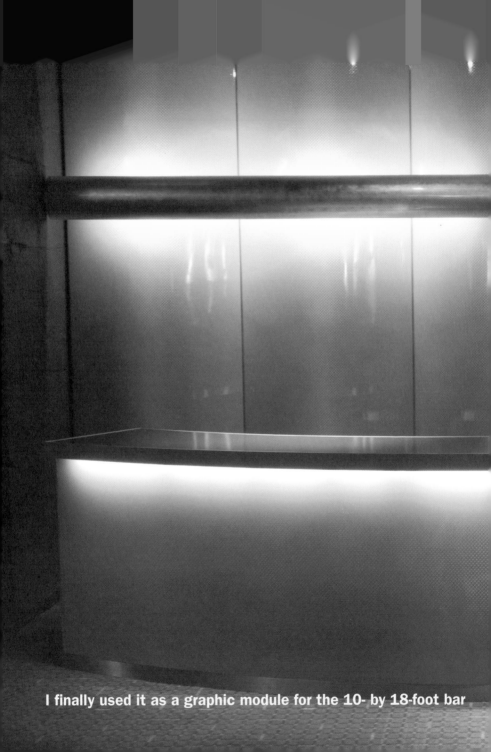

I finally used it as a graphic module for the 10- by 18-foot bar

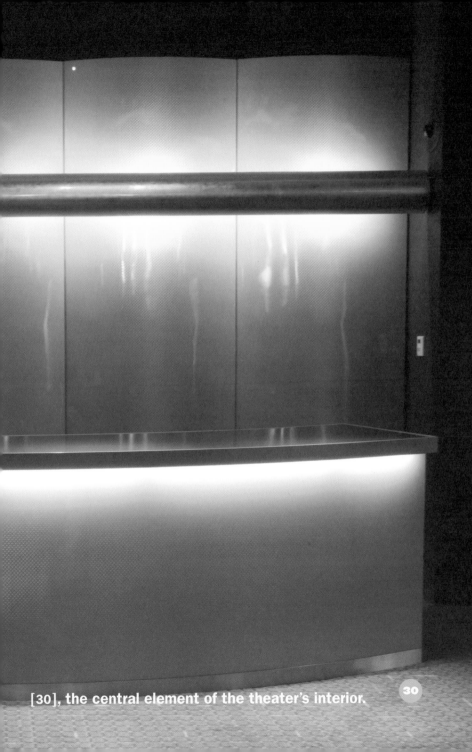

[30], the central element of the theater's interior.

The dot pattern reads as a visual metaphor for a glowing light. The "conversation" between the real reflections created by the gold-leaf light fixture and the highly polished, curved metal panels is the most interesting aspect of the bar.

Light and dark is, of course, one of the inevitable subjects of design. I became increasingly involved in that dialectic as I continued to work on these rugs [31, 32, 33].

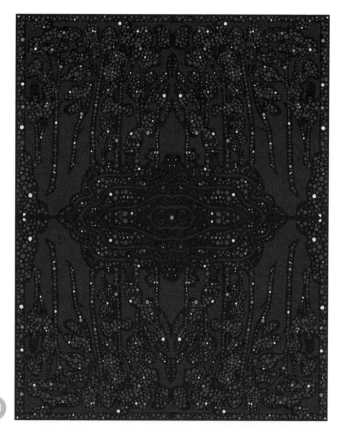

31

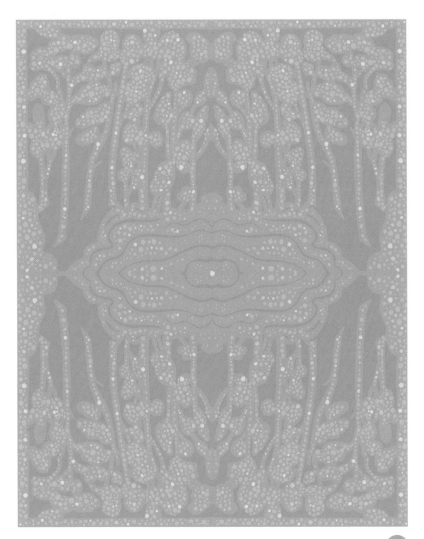

I used one of these studies as the basis for a poster for my shows at the Visual Arts Gallery in 2009 [34]. Ultimately a copy was posted in my ophthalmologist's waiting room.

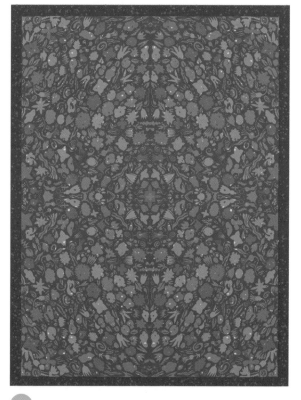

33

Looking

is not

Seeing

For a show of my posters [36], I used another graphic theme from my rug-making activities, this time one that was too complex to be made by hand in Tibet [35].

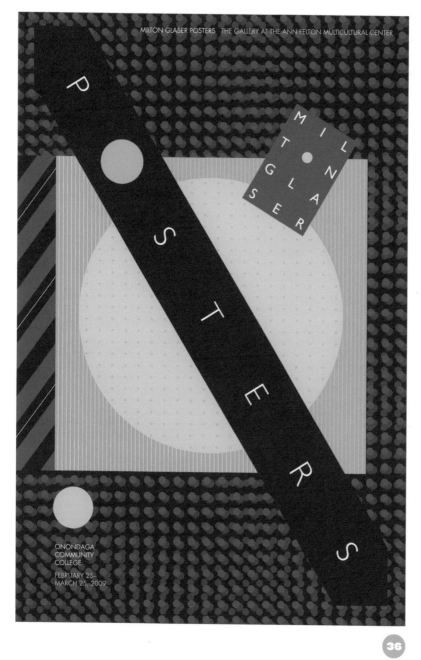

MILTON GLASER POSTERS THE GALLERY AT THE ANN FELTON MULTICULTURAL CENTER

P O S T E R S

MILTON GLASER

ONONDAGA
COMMUNITY
COLLEGE
FEBRUARY 25–
MARCH 25, 2009

36

Another series of patterns involved the creation of a moiré, using simple yellow lines that widen at random. It produces a wavy pattern in the background that doesn't really exist [37, 38].

Another adaptation of a similar idea using a darker palette [39].

37

38

MUSIC AT SOUTHAMPTON

SEASON TWO, SUSTAINABLE TREASURES

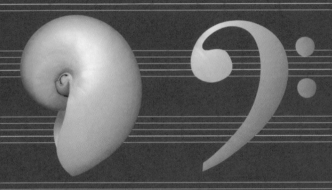

July 10 Joint Concert with PianoFest. Brahms, Liebeslieder
July 17 Jazz with Joel Frahm **July 24** Sylvia McNair (Crossover Cabaret)
July 31 Jill Grove, mezzo-soprano

August 7 Patrick Carfizzi, bass-baritone **August 14** Christine Brewer, soprano
August 21 Jazz with Christopher Higgins (bass), Frank LoCrasto (piano), Greg Ritchie (drums), Rebecca Martin (vocalist)
August 28 Liz McCartney, Broadway Cabaret

THURSDAYS AT 8 PM, AVRAM THEATER

STONY BROOK
SOUTHAMPTON
State University of New York

$35 for single performance tickets $25 for Stony Brook University & Southampton College Alumni, $10 for students $120 for subscription tickets for the four-performance series,
$80 for Alumni. Order tickets online at www.stonybrook.edu/pleasures or by calling (631) 632-8000.

Milton Glaser

The design seemed like a perfect surface for another School of Visual Arts poster called *The Secret of Art* [40], which is also the title of the Visual Arts Theater mural [page 29]. In some way, this poster also engages the basic theme of this exhibition, *In Search of the Miraculous*.

The Secret of Art

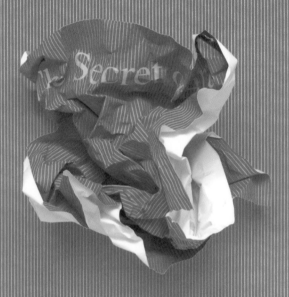

S V A School of VISUAL ARTS

212.592.2050 WWW.SVA.EDU

40

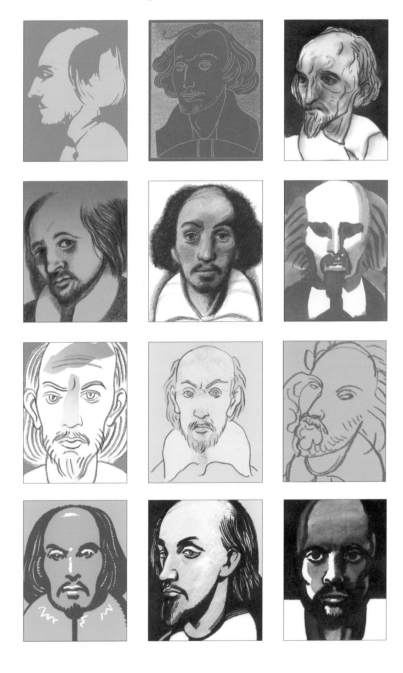

Shakespeare portraits for Theater for a New Audience.

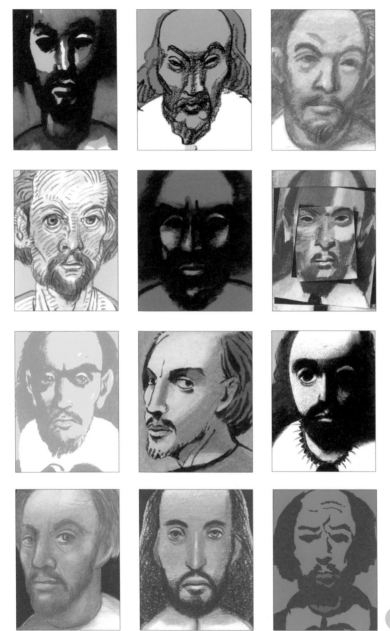

A poster [42] employs many of these portraits. One of these portraits will be used on the new theater façade in Brooklyn, scheduled to open in 2013 [43]. The cubistic Shakespeare bust executed in iridescent automotive paint changes color depending on your visual angle. The organization uses it as their annual award [44].

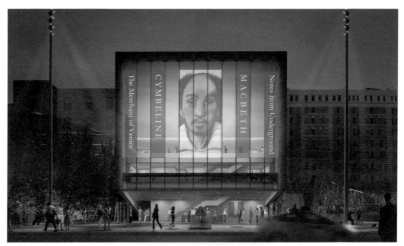

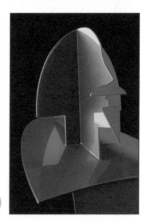

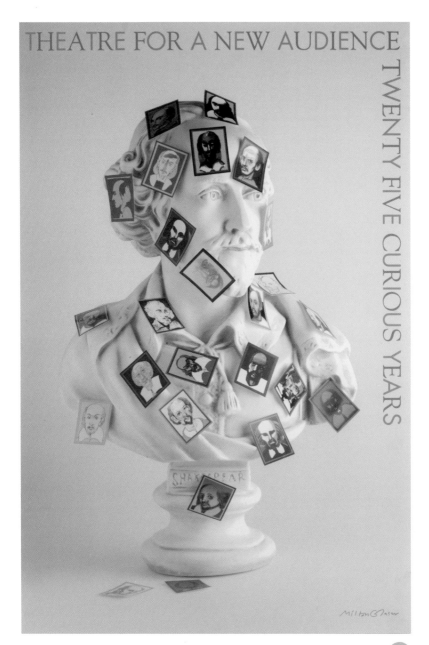

THEATRE FOR A NEW AUDIENCE

TWENTY FIVE CURIOUS YEARS

43

At one point, I wondered if coupling these portraits and the patterns might produce unexpected results [45].

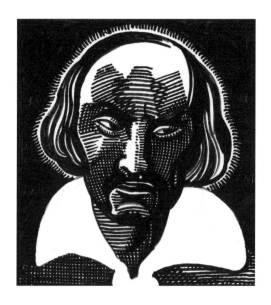

Portrait

45

Pattern

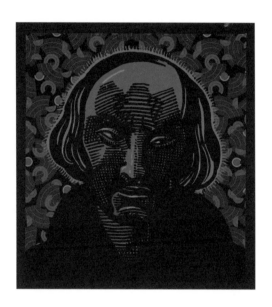

Combination

This image with a complex pattern combined in a more traditional way creates a mat around the drawing [46].

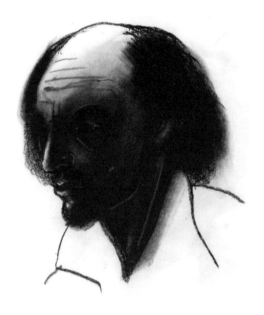

Portrait

46

Pattern

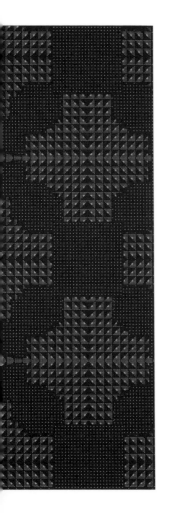

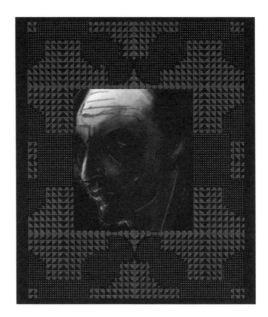

Combination

I used the same pattern to create the Number 4 for an English marketing company [48]. The number itself comes from an alphabet I had designed many years earlier called Glaser Stencil [47].

GLASER STENCIL BOLD

ABCDEFG
HIJKLMNOPQ
RSTUVWXYZ
123456789 () -
"".!?&/%$¢|!:;

47

Incidentally, Shakespeare seems never to be depicted in profile. The portrait combines with a pattern to create this result [49].

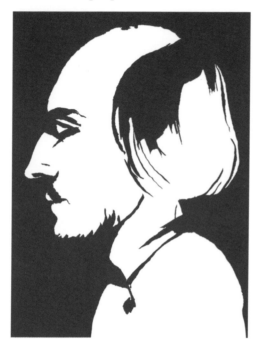

Portrait

49

Pattern

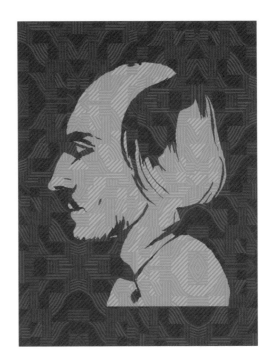

Combination

A classical drawing combined with a cross-hatched texture becomes more interesting [50].

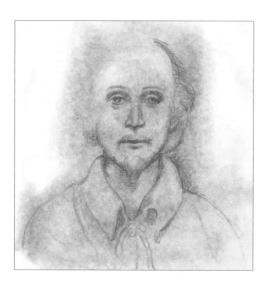

Portrait

Pattern

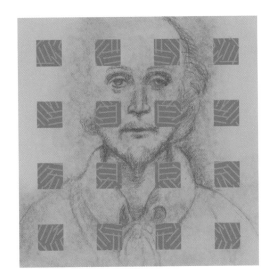

Combination

A very coy Shakespeare combined with these flowers is even more coy [51].

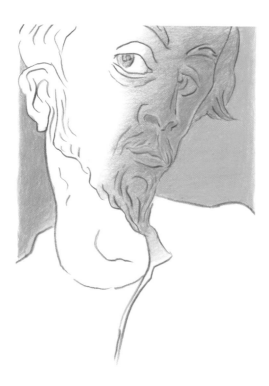

Portrait

Pattern

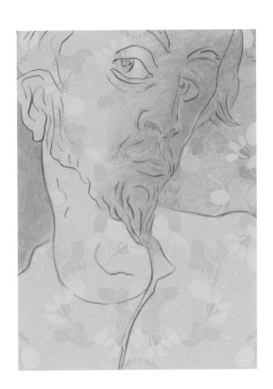

Combination

And finally a sleeping Shakespeare gets a light texture to enrich the image [52].

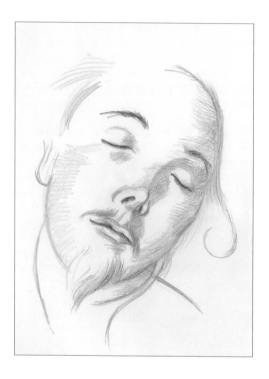

Portrait

Pattern

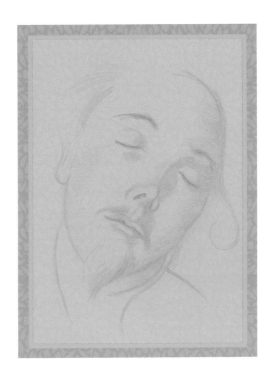

Combination

The combination of the Shakespeare portraits and the patterns led to a new series of prints that explore the point at which portraits become visible. [53–57].

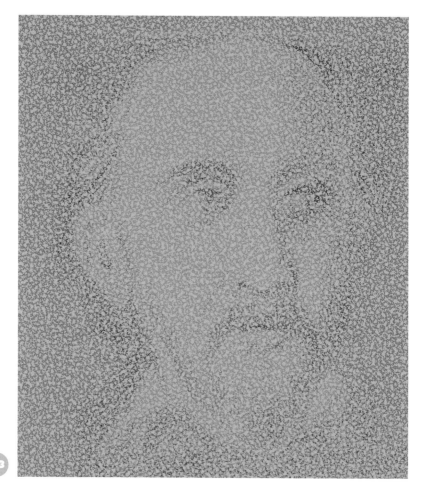

Shakespeare Vanishes "Storm"

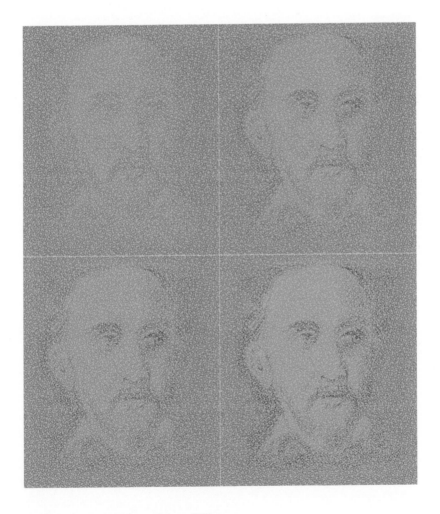

Shakespeare Vanishes "Storm" Phases

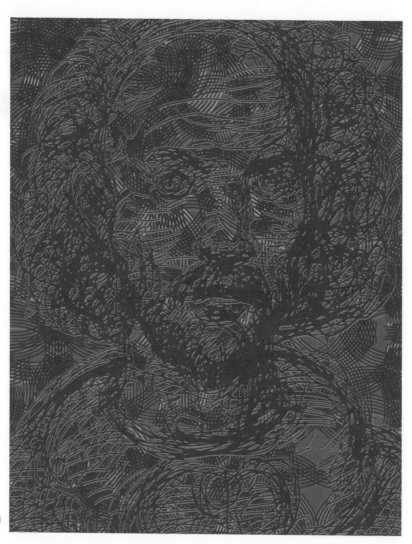

54

Shakespeare Vanishes "Vines"

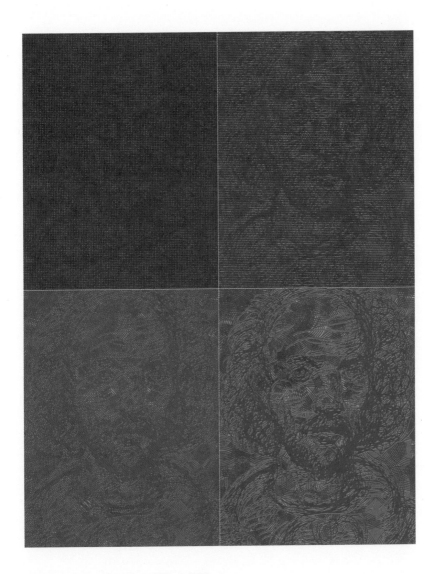

Shakespeare Vanishes "Vines" Phases

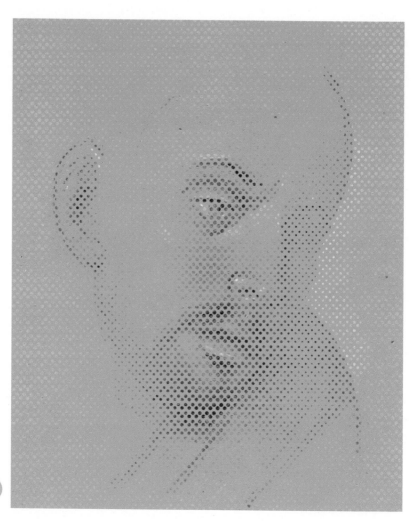

55

Shakespeare Vanishes "Dots"

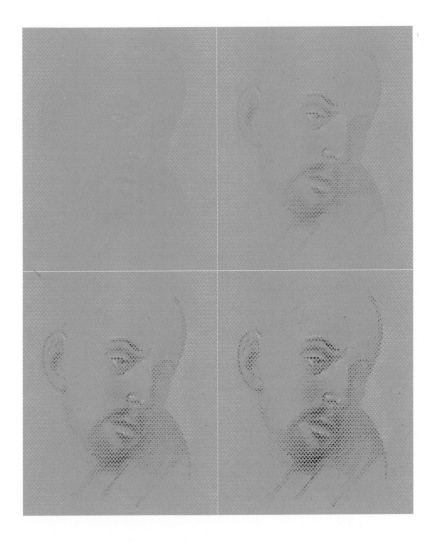

Shakespeare Vanishes "Dots" Phases

Shakespeare Vanishes "Stripes"

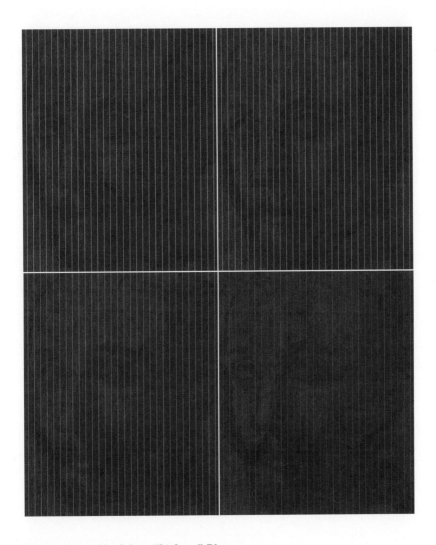

Shakespeare Vanishes "Stripes" Phases

THE CLIENT DIDN'T GET IT

Every designer has a closet full of proposals that were rejected by clients. In many cases, they feel these are their most insightful works. The reasons for rejection are varied and complex, but frequently, these works represent our most transgressive and imaginative efforts. The professional requirement to succeed demands that the work be both understandable and motivating to its target audience.

On the other hand, the imagination feeds on failure and ambiguity, which stimulate the designer's mind and potentially raise it to a new level of understanding. Failure and ambiguity are difficult ideas to sell to a client who simply wants to move more cans of tomatoes.

Two proposed typographic ads for the development of Coney Island [58, 59].

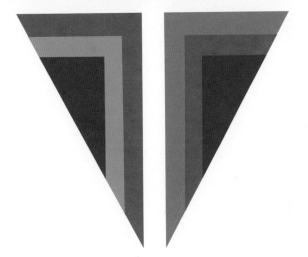

A logo for the Templeton Foundation Prize [60].

Two ads for the Templeton Foundation demonstrating how the organization encompasses many points of view [61, 62]. An ad spread for *The New York Times* for Templeton encouraging diversity of thought [63].

Is there a Multiverse?
Not a Chance.

Lorem Ipsum
Dolor sit amet consectetuer
Adipiscing Elit

Lorem ipsum dolor sit amet, consectetuer adipiscing elit. Aliquam eu elit. Suspendisse potenti. Maecenas sem enim, blandit eget, pharetra et, euismod vitae, augue. Cum sociis natoque penatibus et magnis dis parturient montes, nascetur ridiculus mus. Donec lorem. Integer augue augue, scelerisque pellentesque, elementum non, rutrum vel, neque. Sed vel orci. Phasellus dolor nisi, malesuada in, consequat id, varius id, dui. Suspendisse vulputate, pede at blandit posuere, erat turpis tincidunt metus, vel fermentum enim ligula eget lectus. Donec semper ipsum et dolor. Sed cursus gravida nibh. Duis sed nulla. Donec dapibus augue sit amet nibh. Maecenas sed lacus vel lacus fringilla vestibulum.

Sed nisi nulla, tincidunt sit amet, aliquam et, malesuada vitae, leo. Nam pretium libero adipiscing odio. Ut vehicula est quis mauris. Phasellus odio pede, hendrerit at, elementum dapibus, ullamcorper quis, purus. Nulla tellus neque, tristique vitae, molestie eget, placerat id, ipsum. Suspendisse nibh enim, ullamcorper vel, lacinia sed, ullamcorper nec, sapien. Mauris facilisis. Aenean dictum, dolor ac euismod accumsan, erat est tempus mauris, faucibus laoreet nibh tellus blandit massa. Curabitur mattis tincidunt lorem. Integer congue nonummy elit. Pellentesque quis

JOHN TEMPLETON FOUNDATION

Is there a Multiverse?
There Certainly is.

Max Tegmark
Professor of Physics
Princeton University

Lorem ipsum dolor sit amet, consectetuer adipiscing elit. Aliquam eu elit. Suspendisse potenti. Maecenas sem enim, blandit eget, pharetra et, euismod vitae, augue. Cum sociis natoque penatibus et magnis dis parturient montes, nascetur ridiculus mus. Donec lorem. Integer augue augue, scelerisque pellentesque, elementum non, rutrum vel, neque. Sed vel orci. Phasellus dolor nisi, malesuada in, consequat id, varius id, dui. Suspendisse vulputate, pede at blandit posuere, erat turpis tincidunt metus, vel fermentum enim ligula eget lectus. Donec semper ipsum et dolor. Sed cursus gravida nibh. Duis sed nulla. Donec dapibus augue sit amet nibh. Maecenas sed lacus vel lacus fringilla vestibulum.

Sed nisi nulla, tincidunt sit amet, aliquam et, malesuada vitae, leo. Nam pretium libero adipiscing odio. Ut vehicula est quis mauris. Phasellus odio pede, hendrerit at, elementum dapibus, ullamcorper quis, purus. Nulla tellus neque, tristique vitae, molestie eget, placerat id, ipsum. Suspendisse nibh enim, ullamcorper vel, lacinia sed, ullamcorper nec, sapien. Mauris facilisis. Aenean dictum, dolor ac euismod accumsan, erat est tempus mauris, faucibus laoreet nibh tellus blandit massa. Curabitur mattis tincidunt lorem. Integer congue nonummy elit. Pellentesque quis lacus a odio vulputate convallis.

We're the john templeton foundation and we're a world apart. something in us resists doing what everyone else is doing, and so we fund teams of scholars, scientists and high-level thinkers to tackle the big questions. our founder, sir john templeton's motto: "how little we know, how much to learn."

Does the universe have a purpose?

Improbable.

Steven Weinberg
Nobel Prize winner in physics
University of Texas at Austin

Lorem ipsum dolor sit amet, consectetuer adipiscing elit. Aliquam eu elit. Suspendisse potenti. Maecenas sem enim, blandit eget, pharetra et, euismod vitae, augue. Cum sociis natoque penatibus et magnis dis parturient montes, nascetur ridiculus mus. Donec lorem. Integer augue augue, scelerisque pellentesque, elementum non, rutrum vel, neque. Sed vel orci. Phasellus dolor nisi, malesuada in, consequat id, varius id, dui. Suspendisse vulputate, pede at blandit posuere, erat turpis tincidunt metus, vel fermentum enim ligula eget lectus. Donec semper ipsum et dolor. Sed cursus gravida nibh. Duis sed nulla. Donec dapibus augue sit amet nibh. Maecenas sed lacus vel lacus fringilla vestibulum.

Sed nisi nulla, tincidunt sit amet, aliquam et, malesuada vitae, leo. Nam pretium libero adipiscing odio. Ut vehicula est quis mauris. Phasellus odio pede, hendrerit at, elementum dapibus, ullamcorper quis, purus. Nulla tellus neque, tristique vitae, molestie eget, placerat id, ipsum. Suspendisse nibh enim, ullamcorper vel, lacinia sed, ullamcorper nec, sapien. Mauris facilisis. Aenean dictum, dolor ac euismod accumsan, erat est tempus mauris, faucibus laoreet nibh tellus blandit massa. Curabitur mattis tincidunt lorem. Integer congue nonummy elit. Pellentesque quis

Absolutely!

Paul Davies
Astrobiologist
Arizona State University

Lorem ipsum dolor sit amet, consectetuer adipiscing elit. Aliquam eu elit. Suspendisse potenti. Maecenas sem enim, blandit eget, pharetra et, euismod vitae, augue. Cum sociis natoque penatibus et magnis dis parturient montes, nascetur ridiculus mus. Donec lorem. Integer augue augue, scelerisque pellentesque, elementum non, rutrum vel, neque. Sed vel orci. Phasellus dolor nisi, malesuada in, consequat id, varius id, dui. Suspendisse vulputate, pede at blandit posuere, erat turpis tincidunt metus, vel fermentum enim ligula eget lectus. Donec semper ipsum et dolor. Sed cursus gravida nibh. Duis sed nulla. Donec dapibus augue sit amet nibh. Maecenas sed lacus vel lacus fringilla vestibulum.

Sed nisi nulla, tincidunt sit amet, aliquam et, malesuada vitae, leo. Nam pretium libero adipiscing odio. Ut vehicula est quis mauris. Phasellus odio pede, hendrerit at, elementum dapibus, ullamcorper quis, purus. Nulla tellus neque, tristique vitae, molestie eget, placerat id, ipsum. Suspendisse nibh enim, ullamcorper vel, lacinia sed, ullamcorper nec, sapien. Mauris facilisis. Aenean dictum, dolor ac euismod accumsan, erat est tempus mauris, faucibus laoreet nibh tellus blandit massa. Curabitur mattis tincidunt lorem. Integer congue nonummy elit. Pellentesque quis lacus s odio vulputate convallis.

JOHN TEMPLETON FOUNDATION

We're the John Templeton Foundation and we're a world apart. Our contrarian nature guides us to resist doing what everyone else is doing in the world of philanthropy. And so we fund teams of scholars, scientists and high-level thinkers to tackle the Really Big Questions.

The Open Mind'

In an odd way...When your hand opened this page, you opened a Mind. And the endless possibilities of the Open Mind are what drive the John Templeton Foundation, and keep us a world apart.

We exist only to gather together leading scientists, researchers, and other top thinkers, then fund their probings into the Big Questions.

Nothing excites us more than backing the rigorous research and cutting-edge scholarship that is at the heart of all new discoveries and human progress.

We're the john templeton foundation and we're a world apart. Something in us resists doing what everyone else is doing. And so we fund teams of scholars, scientists and high-level thinkers to tackle the big questions. Our founder, sir john templeton's motto: "how little we know, how much to learn."

The Closed Mind

In another way...as you close this page, you'll close a Mind. And to us, the sad limits of the Closed Mind are anathema. In fact, keeping an Open Mind is what keeps the Templeton Foundation on its toes.

We've never met a Big Question we didn't hope to solve. But we don't do the solving. Instead, we create teams of the finest minds we can find, fund them generously, then turn them loose. With no strings attached.

That's our story: Supporting science. Pursuing the Big Questions.

JOHN TEMPLETON FOUNDATION

Matched bottles for Cachaça and Caipirinha [64]. A logo for an art museum in Los Angeles [65]. A new icon for the Republican party [66].

INSTITUTE OF CONTEMPORARY ART LOS ANGELES

65

The Republicants

66 No compassion, No solutions

[*Following Pages*] Advertising for the Brooklyn Brewery [67]. A bus shelter campaign for the Minneapolis Institute of Art [68]. An entry door proposal for the Brooklyn Brewery [69].

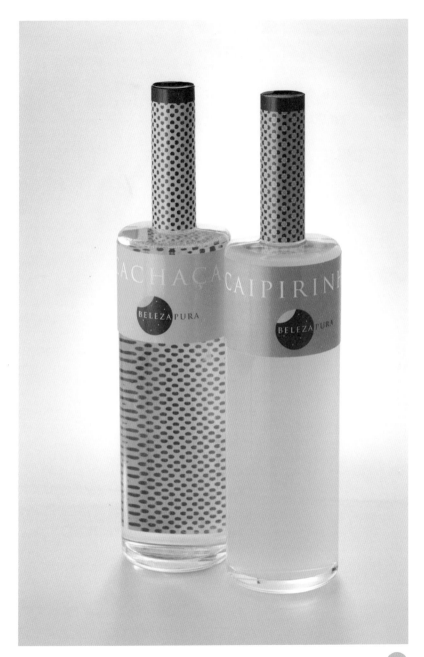

The net worth of New York's most desirable couples

$52
Pastrami Sandwich & East India Pale Ale
11 MADISON PARK
www.2ndavedeli.com 212-889-3000

$28
Sushi & Pennant Ale
CO.
www.2ndavedeli.com 212-889-3000

$30
Black Label Burger & Brooklyn Pilsner
MINETTA TAVERN
www.2ndavedeli.com 212-889-3000

$28
Margarita Pizza & Pennant Ale
CO.
www.2ndavedeli.com 212-889-3000

$52
Sole Amondine Filet & East India Pale Ale
11 MADISON PARK
www.2ndavedeli.com 212-889-3000

$52
Grilled Sirloin & Winter Ale
PETER LUGER'S STEAKHOUSE
www.2ndavedeli.com 212-889-3000

$28
Spaghetti Bolognese & Brown Ale
DA UMBERTO
www.da.com 212-889-3000

 BROOKLYN BREWERY, 79 NORTH 11TH STREET, BROOKLYN, NEW YORK

HAPPY HOUR FRIDAYS 6-11PM; TOURS SATURDAYS AND SUNDAYS AT 1, 2, 3, AND 4PM BROOKLYNBREWERY.COM

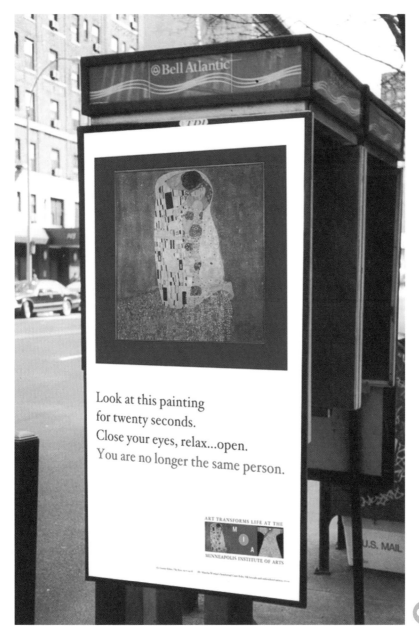

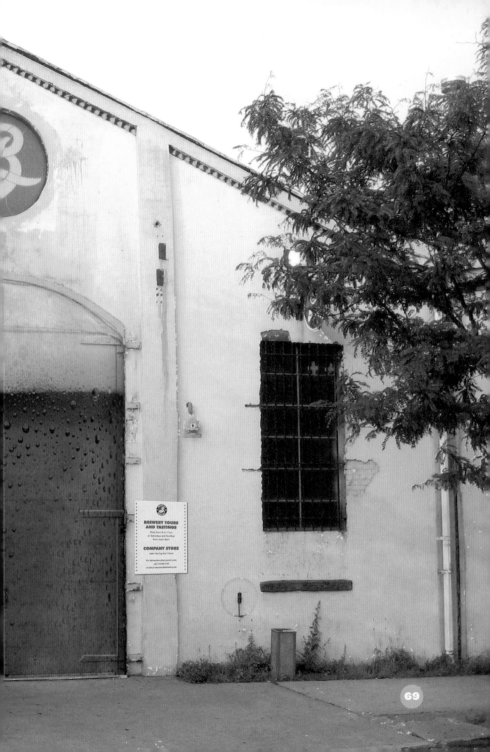

STUMBLING IN THE DARK

The following prints continue the inquiry into the nature of perception. Does the difficulty of seeing these images—because of their darkness and lack of contrast—provoke the viewer to pay more attention? Or does it produce indifference and irritation? The interval between looking and seeing is one of communication's most profound issues. Designers often comment that in the act of creating what turns out to be their best work, they often experience a sense of doubt and confusion. How could it be otherwise? Certainty is a closing of the mind. To create the new requires doubt. Or, to quote old man Picasso, "Art is a lie that reveals the truth."

The theme of darkness and perceptual difficulty continued to interest me, and I developed a series of dark prints [70, 71] where understanding what you are looking at requires attentiveness and patience.

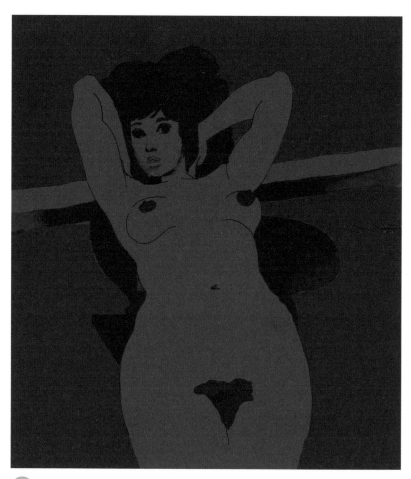

70

Three limited edition giclée prints. *Dark Landscape* [72].
Dark Fruit with Highlights [73]. *Dark-Eyed Woman* [74].

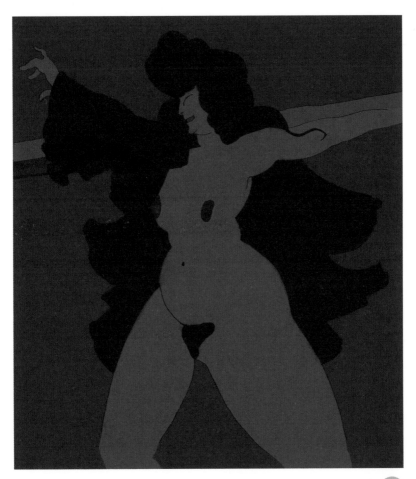

71

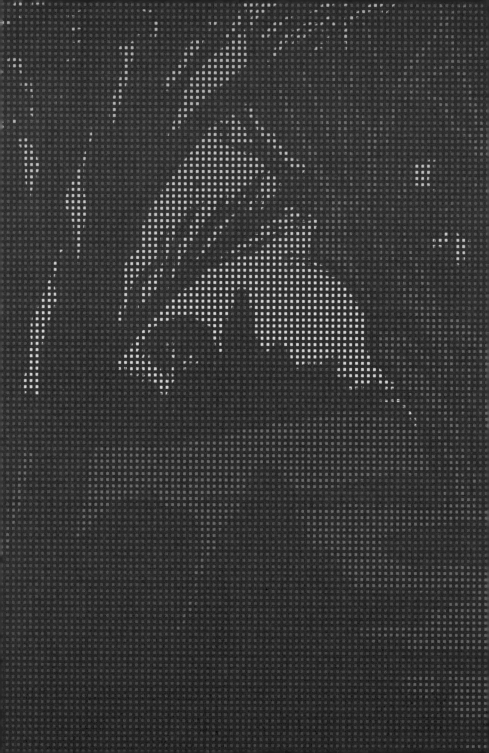

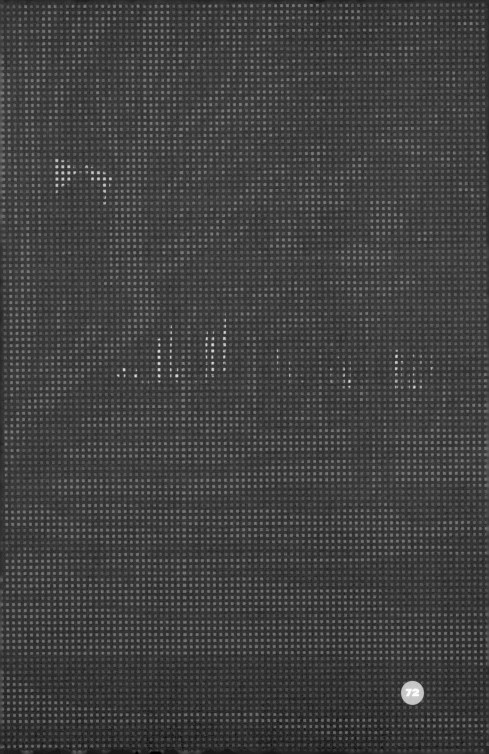

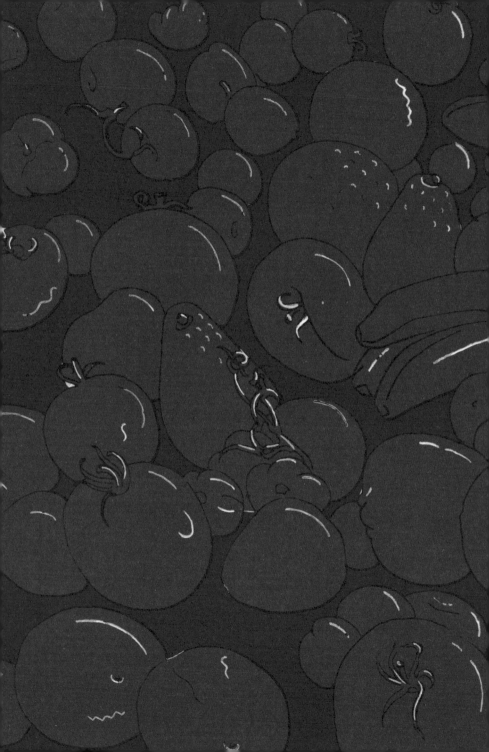

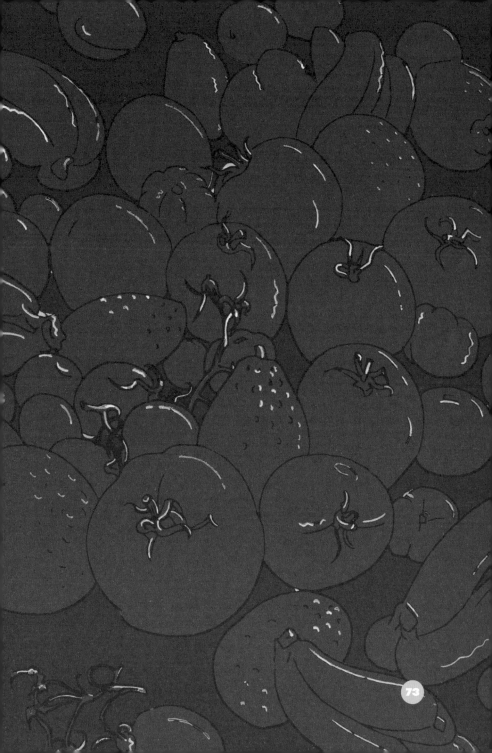

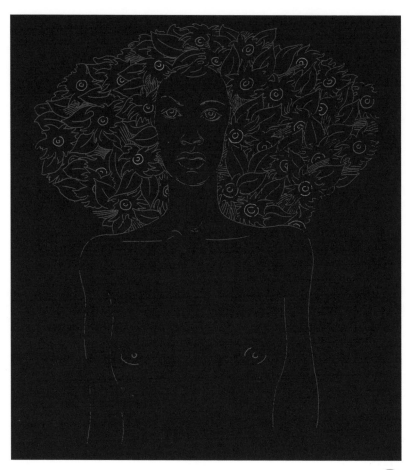

Addio.

74